Roly-poly Round Seals!

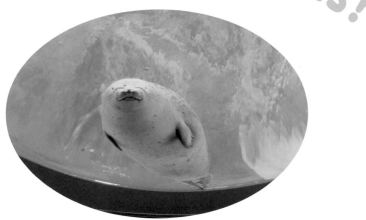

PIE International

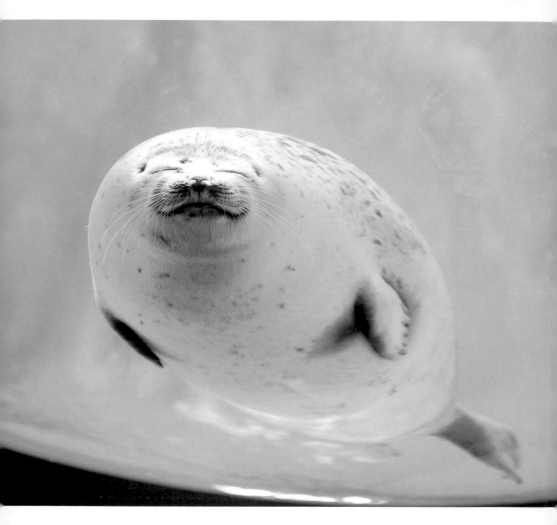

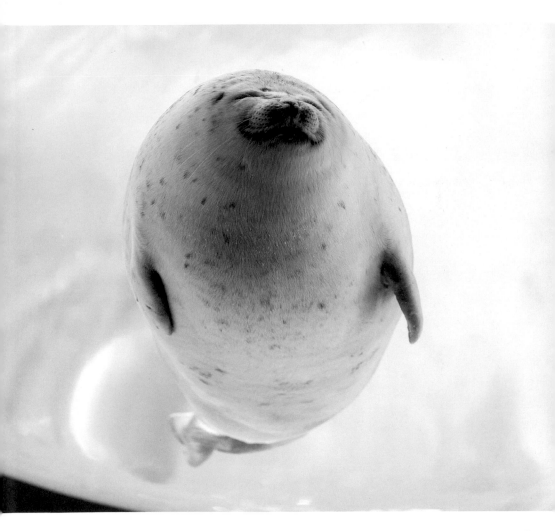

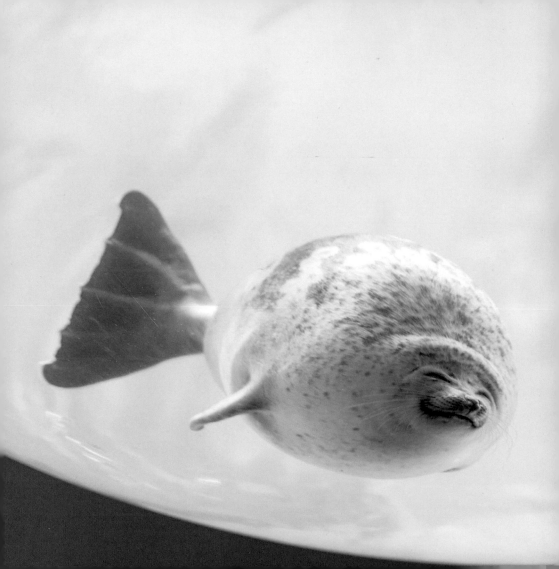

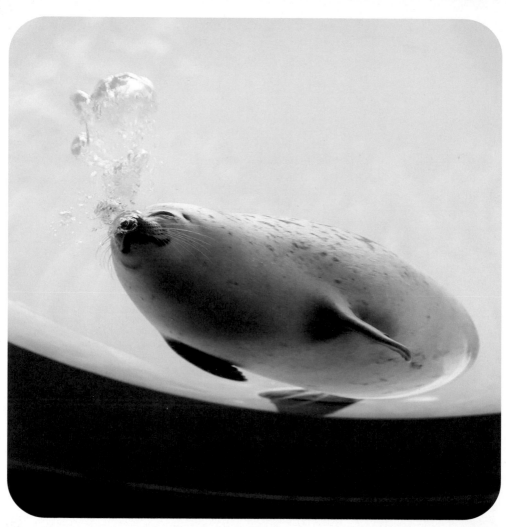

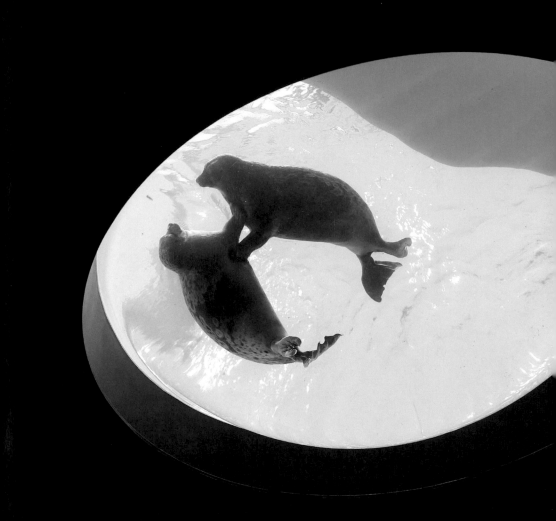

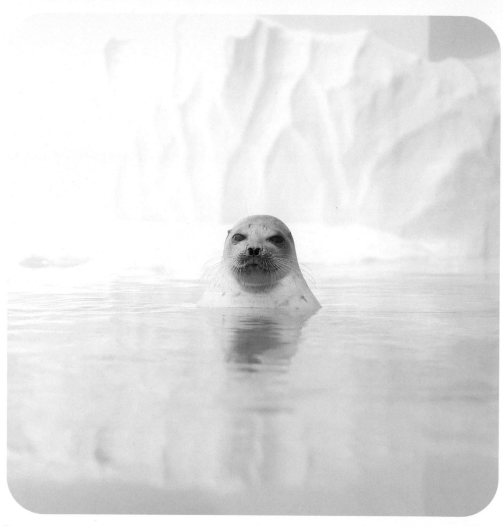

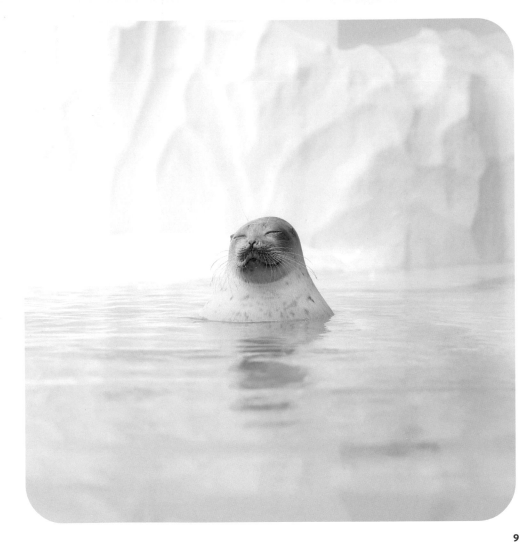

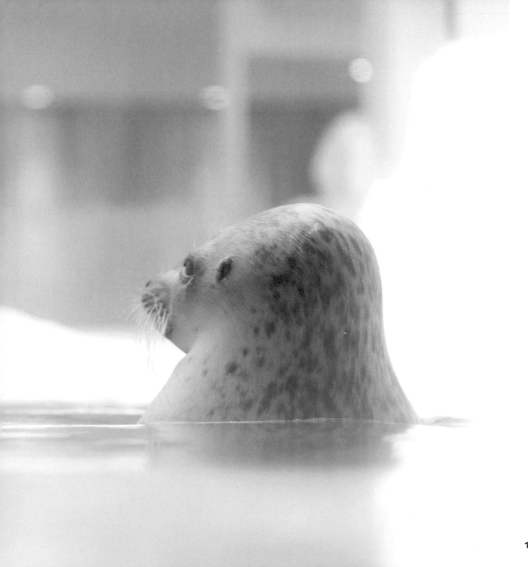

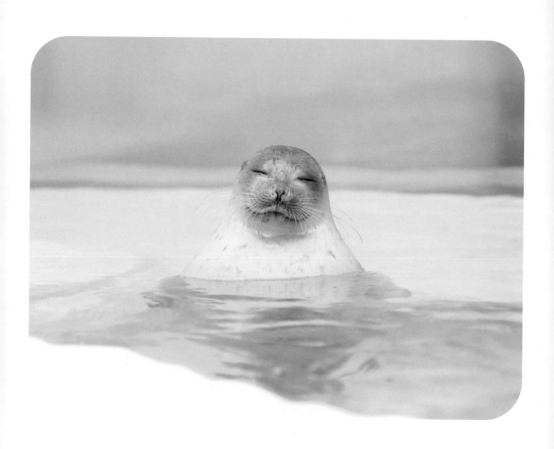

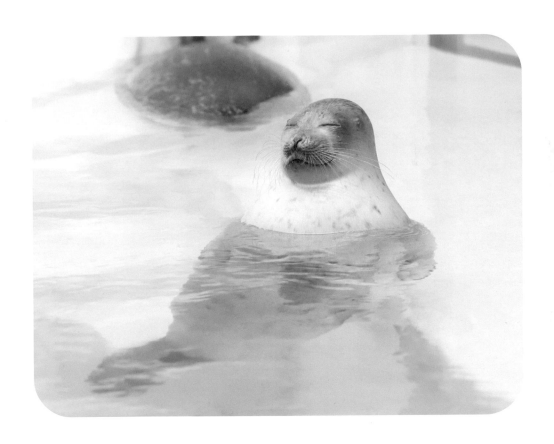

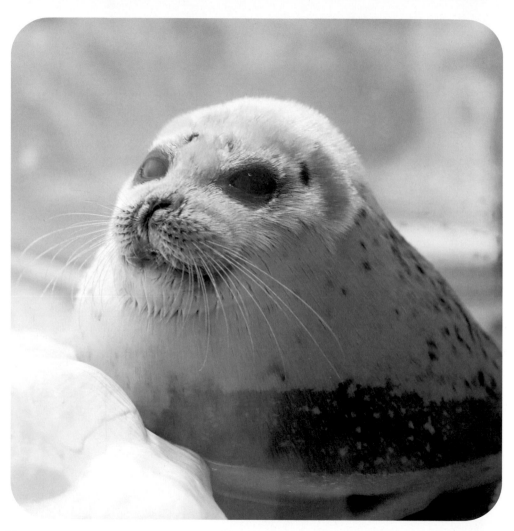

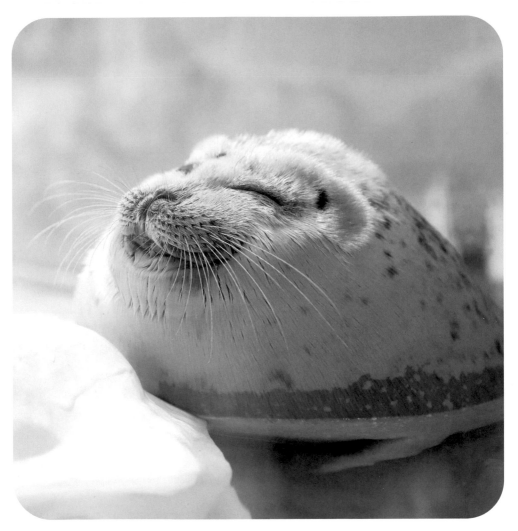

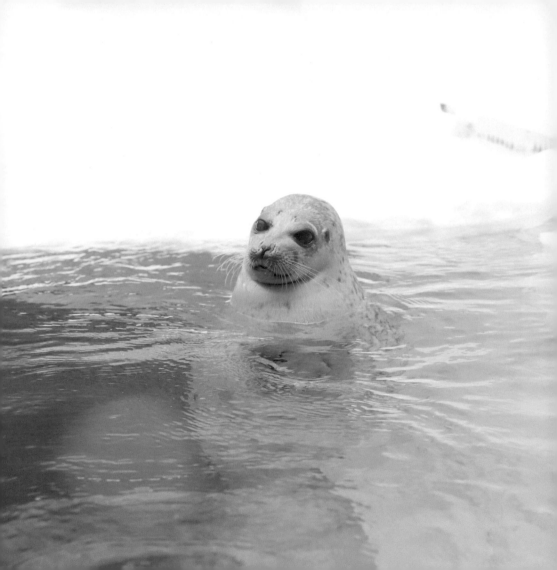

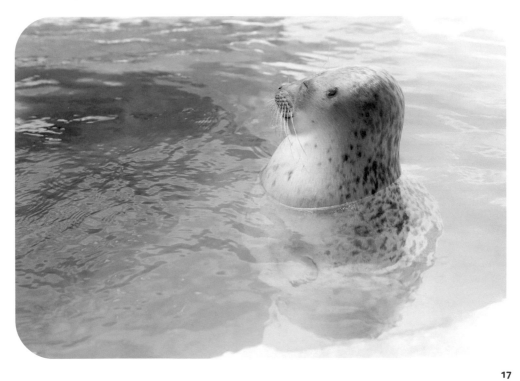

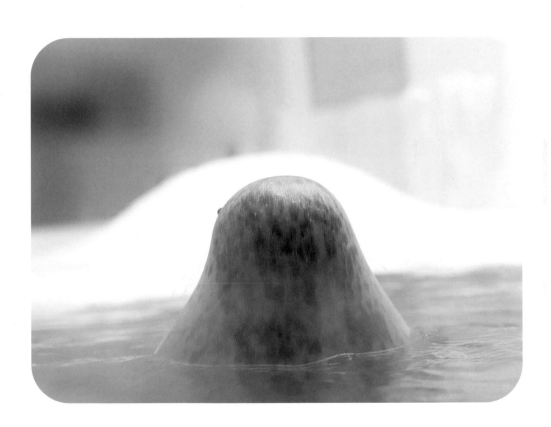

Ringed seals at Osaka Aquarium Kaiyukan

Kaiyukan is home to three ringed seals, each with Japanese names referring to weather conditions in cold regions.

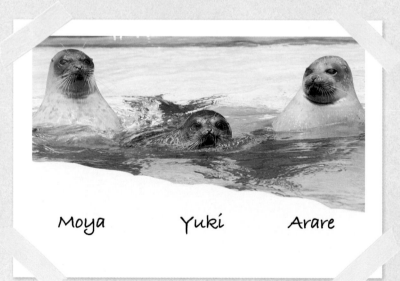

Moya Yuki Arare

No.001

Arare
Female

Named for "hail," Arare's coat is whitish with black-pattern areas on her back.

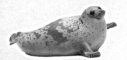

No.002

Yuki
Female

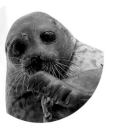

Yuki's name means "snow." She's got a small face, and she's often seen pulling her neck in to take a nap.

No.003

Moya
Male

Moya, whose name means "haze," is distinguished by the wrinkles on his face, and his front legs are longer than his back legs.

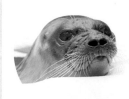

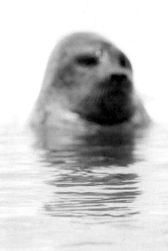

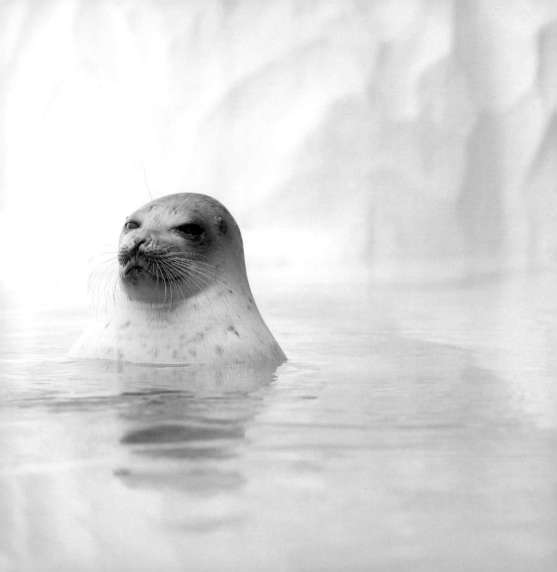

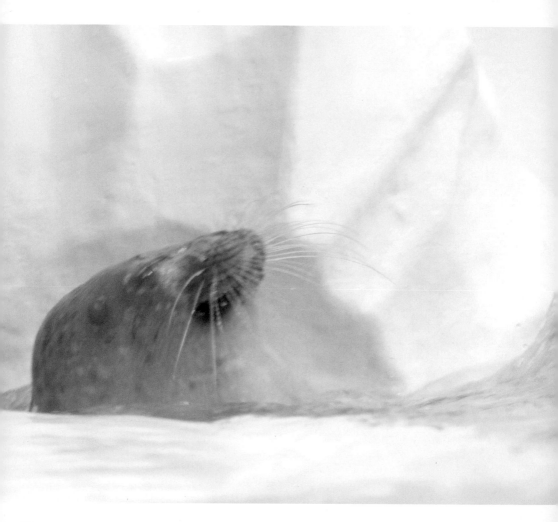

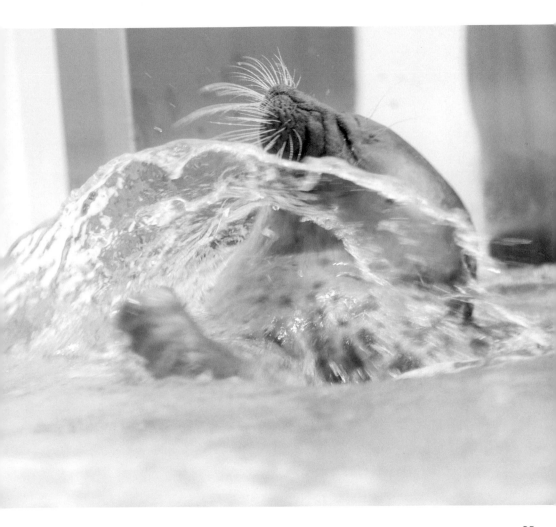

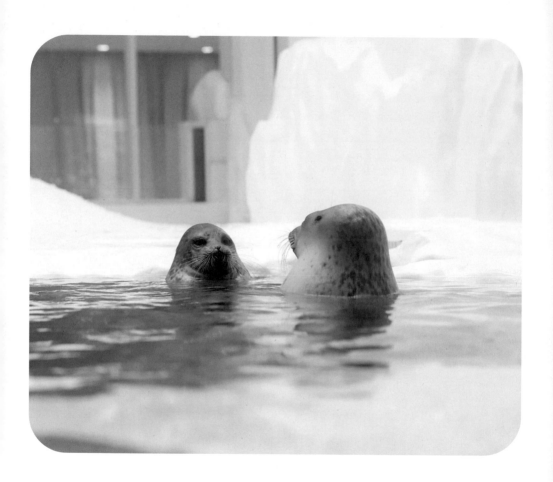

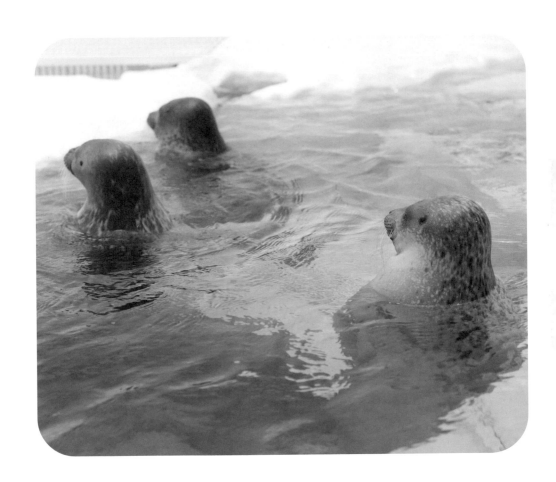

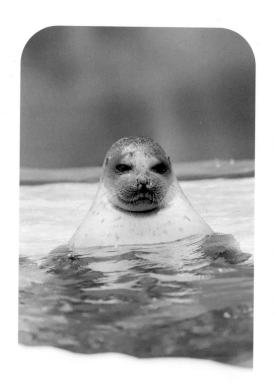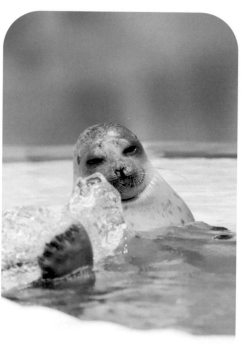

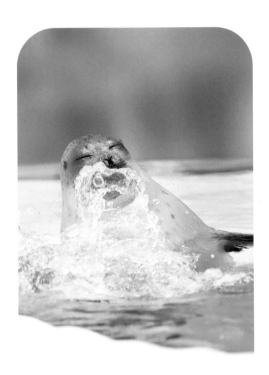
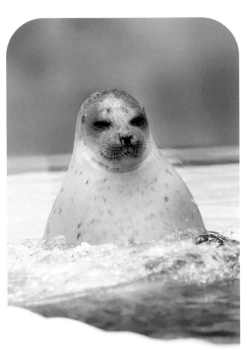

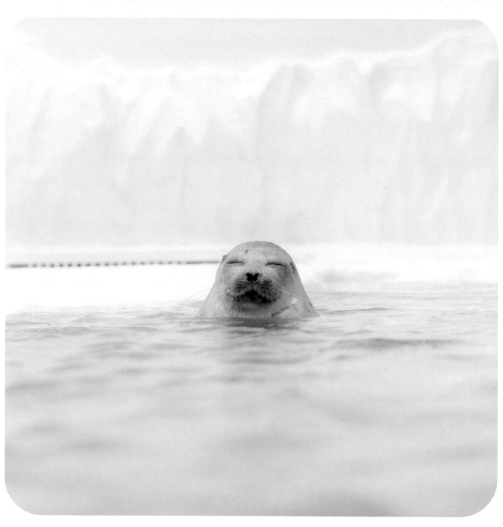

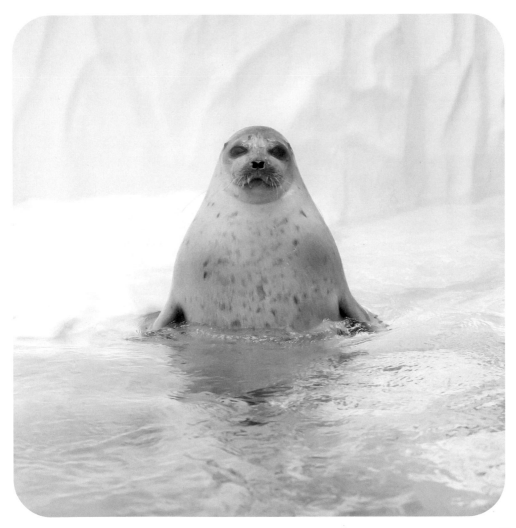

Column 1

What's the difference between a seal and a sea lion?

Seals and sea lions are both pinnipeds, which are characterized by fin-shaped feet. Though they may look similar at first glance, they are actually different species. Let's have a look at some of their characteristics.

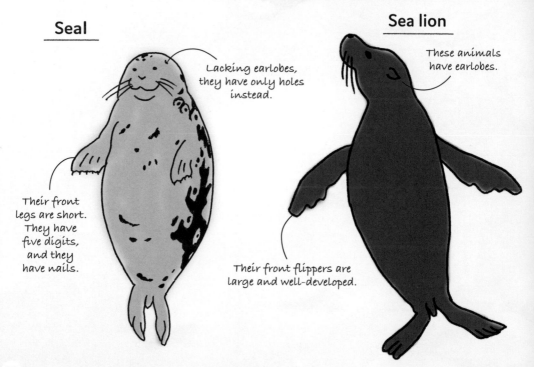

Seal

Lacking earlobes, they have only holes instead.

Their front legs are short. They have five digits, and they have nails.

Sea lion

These animals have earlobes.

Their front flippers are large and well-developed.

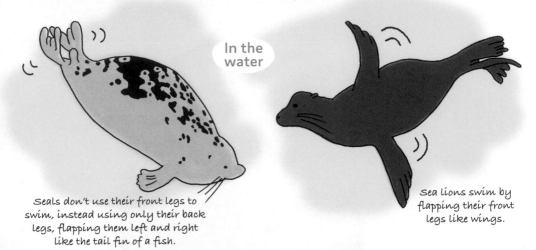

In the
water

Seals don't use their front legs to
swim, instead using only their back
legs, flapping them left and right
like the tail fin of a fish.

Sea lions swim by
flapping their front
legs like wings.

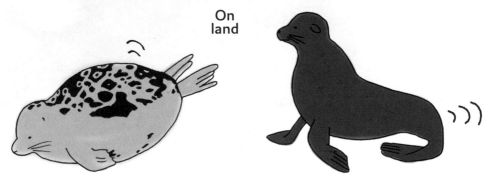

On
land

Using neither their front or
back legs, seals instead use their
entire bodies to crawl along.

Bending their back legs forward,
sea lions use all four limbs to
move on land.

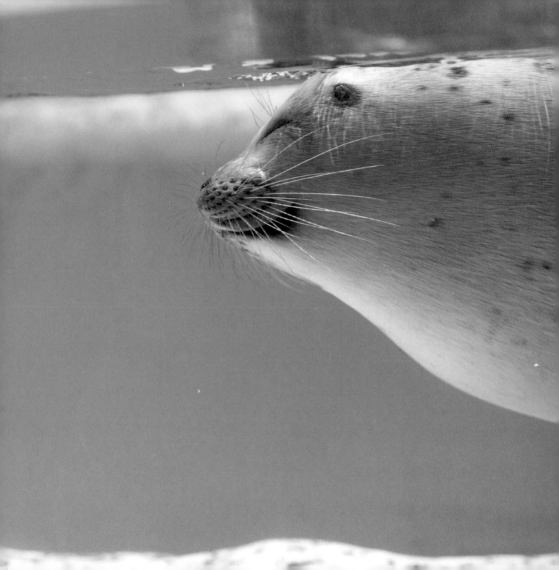

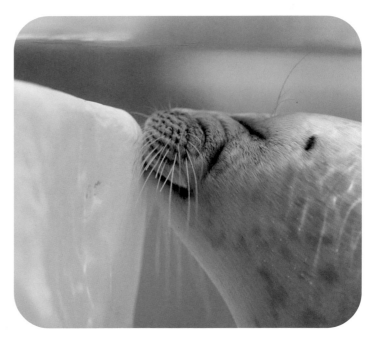

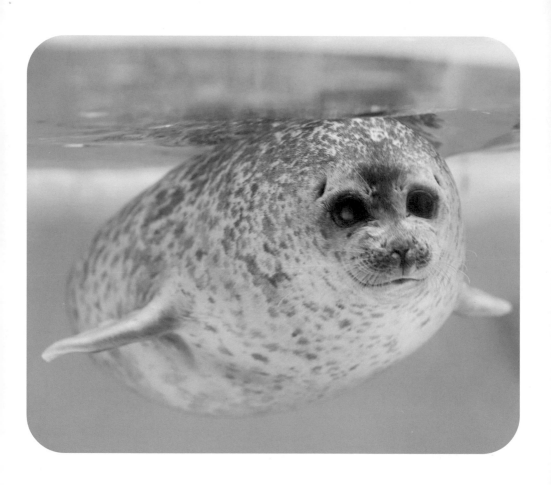

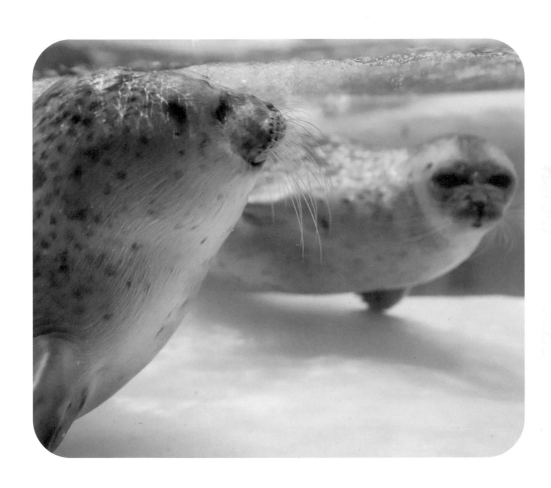

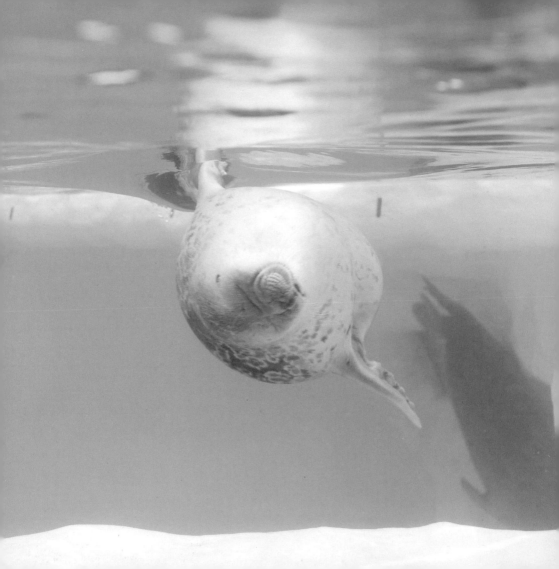

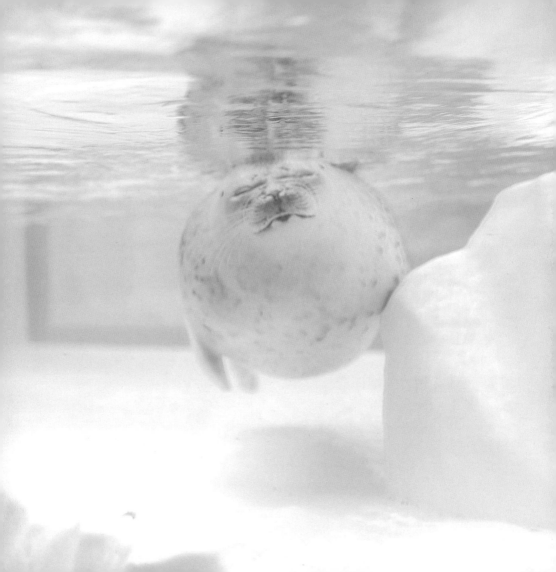

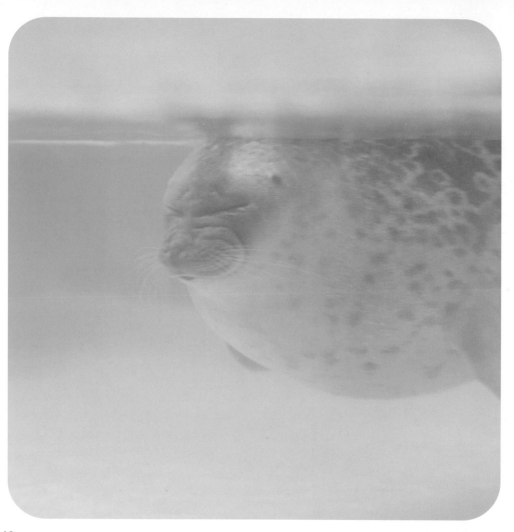

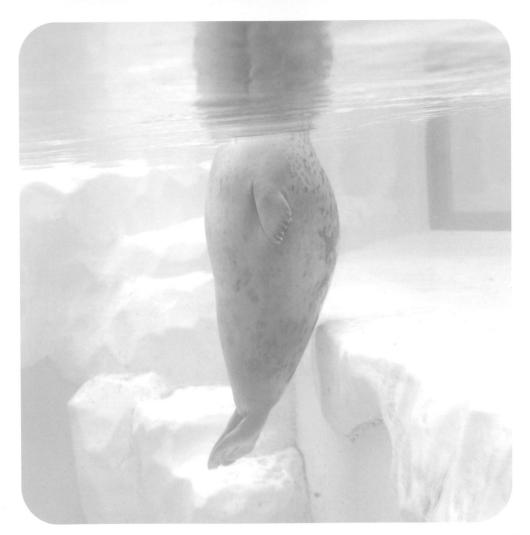

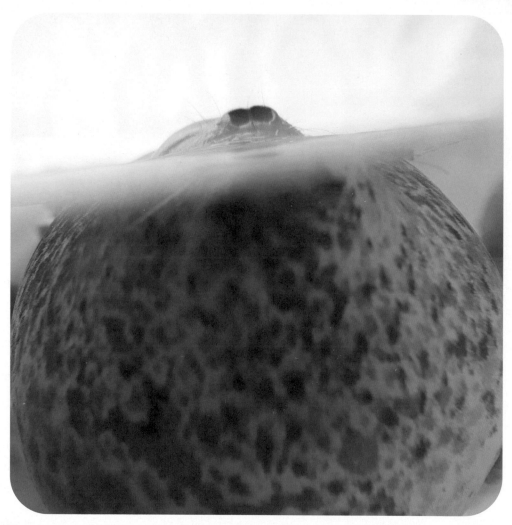

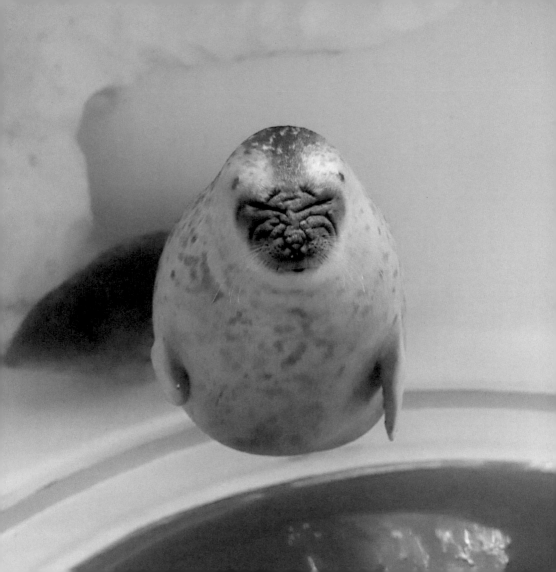

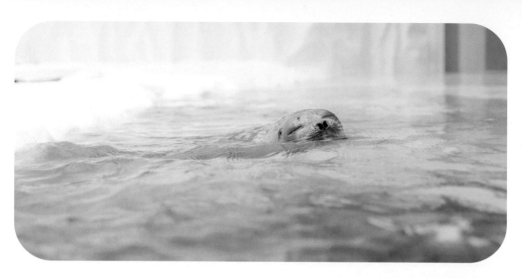

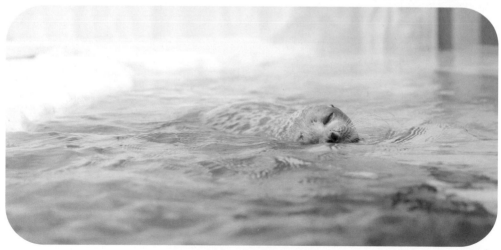

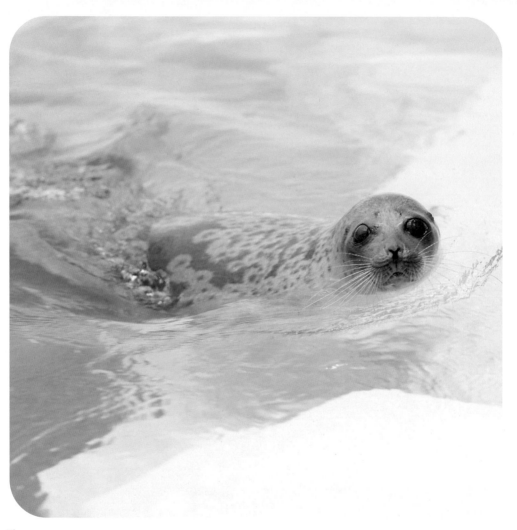

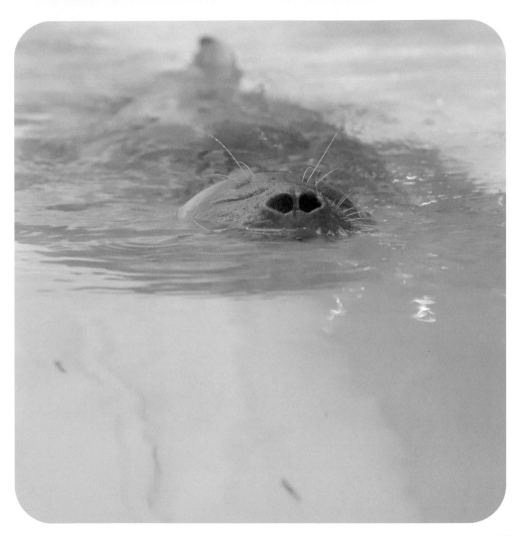

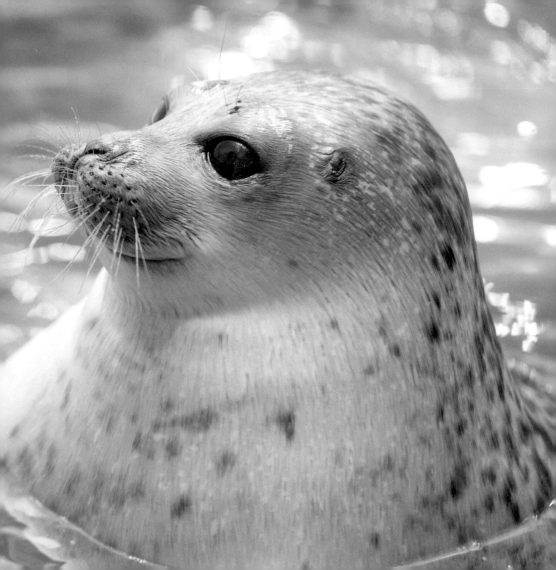

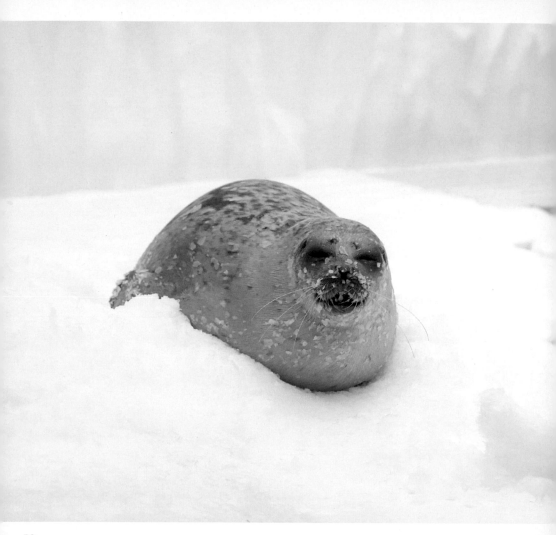

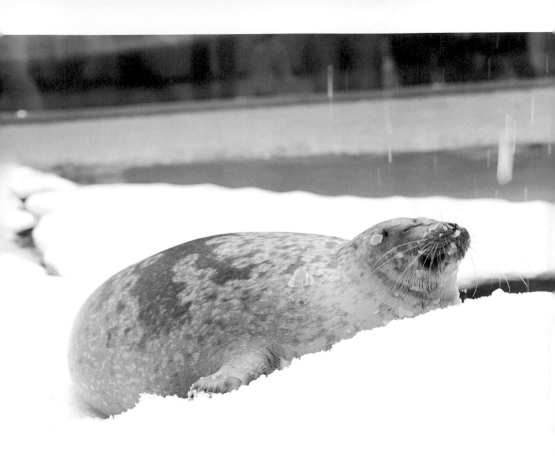

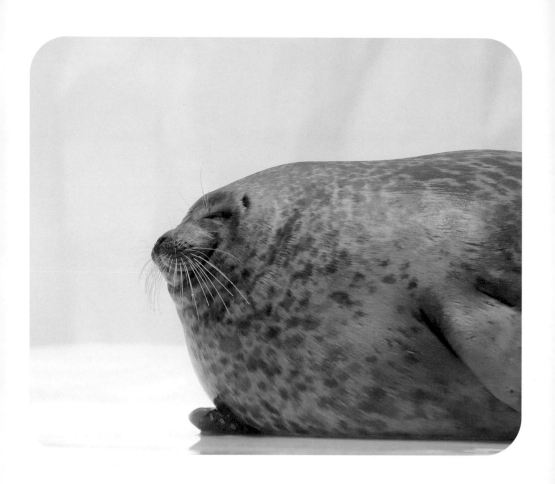

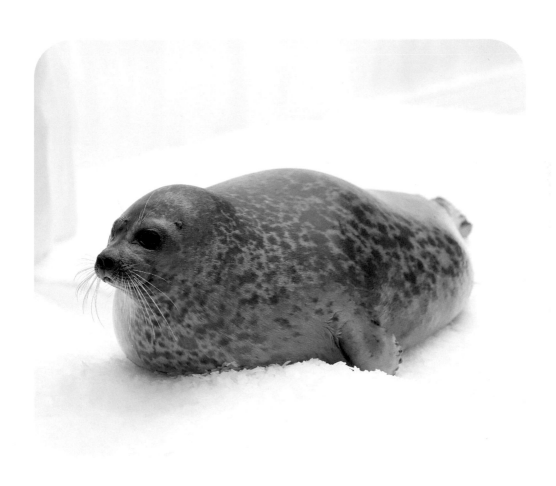

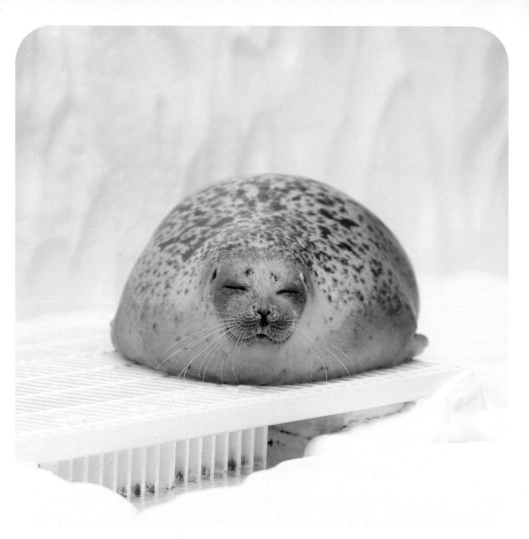

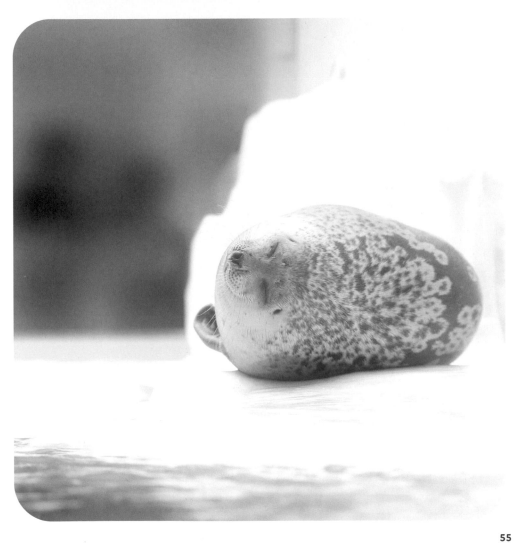

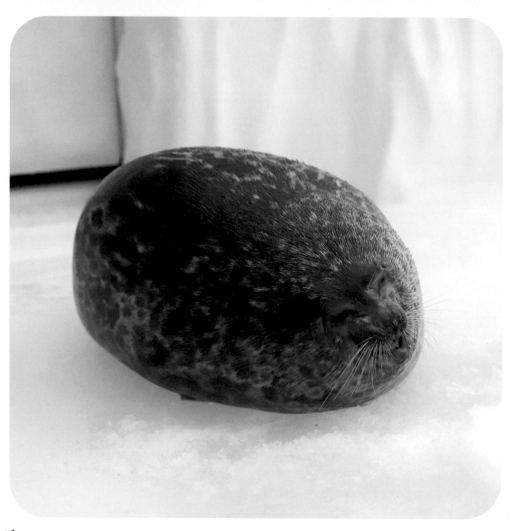

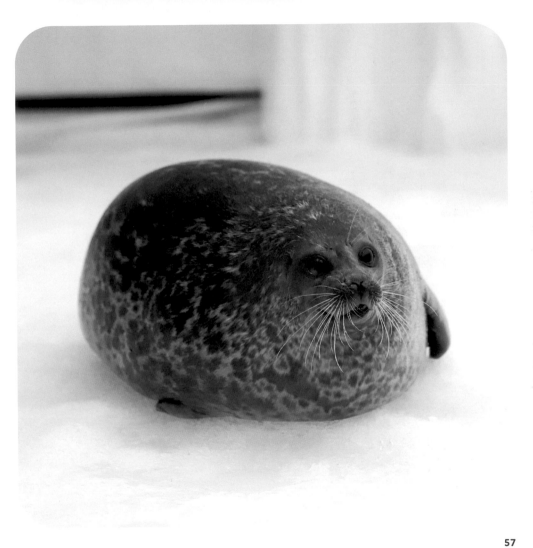

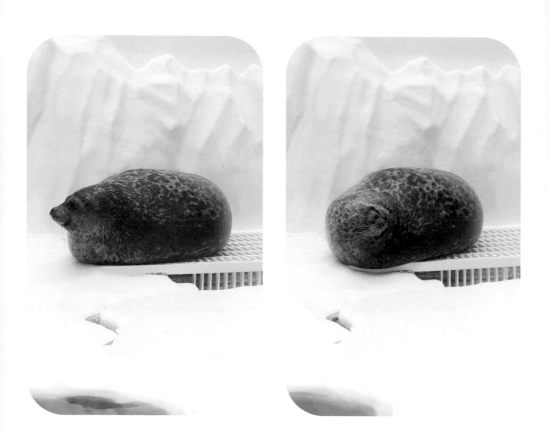

Column 2

Different varieties of seals

We call them all seals, but in fact there are various kinds. Let's introduce some of them here.

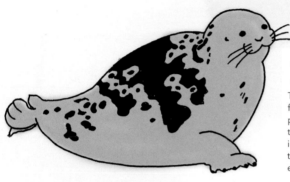

Ringed seal
Length: 3' 7"-4' 3"
Weight: 110-198 lb

This is the smallest of the phocids or seal family. The name originates with the ringed patterns on the seal's back. The animal uses the nails on its front legs to dig air holes in ice. At times, the ring seal pops its head through these holes to make sure its natural enemy, the polar bear, isn't lurking around.

Baikal seal
Length: Approx. 4' 3"
Weight: Approx. 165 lb

This seal, which makes its home in Lake Baikal, Russia, is the world's only freshwater seal. It is noted for its large, round eyes.

Spotted seal
Length: Approx. 5' 3"
Weight: Approx. 220 lb

This seal sports black spots all on its body, notably on its back. The babies are covered in white, fluffy fur, which falls out 2–3 weeks after birth, at which time the black spots begin to appear.

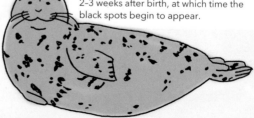

Bearded seal

Length: 7' 3"–7' 7"
Weight: Approx.

This seal is noted for its long and prominent "beard." During the mating season, the male calls the female with such a strange sound under the water; you'd think you're about to see a ghost!

Ribbon seal

Length: Approx. 5' 3"
Weight: Approx. 210 lb

The ribbon seal is named for the white lines forming the shape of a ribbon on the seal's black body. This is a characteristic of the adult males, while the female and young ones lack distinct patterns.

Hooded seal

Male: Length: Approx. 8' 6"
Weight: Approx. 882 lb
Female: Length: Approx. 6' 7"
Weight: Approx. 661 lb

This seal is named for the male's nose, which he can blow up like a balloon that also looks like a red scarf or "hood." These "balloons" are often seen when two males are fighting.

Male

Southern elephant seal

Male: Length: Approx. 16' 1"
Weight: Approx. 5,290 lb
Female: Length: Approx. 9' 10"
Weight: Approx. 1,500 lb

This seal, the biggest of the phocid or seal family, has a large nose, like that of an elephant. One male may have a "harem" of 30-50 females.

Female

61

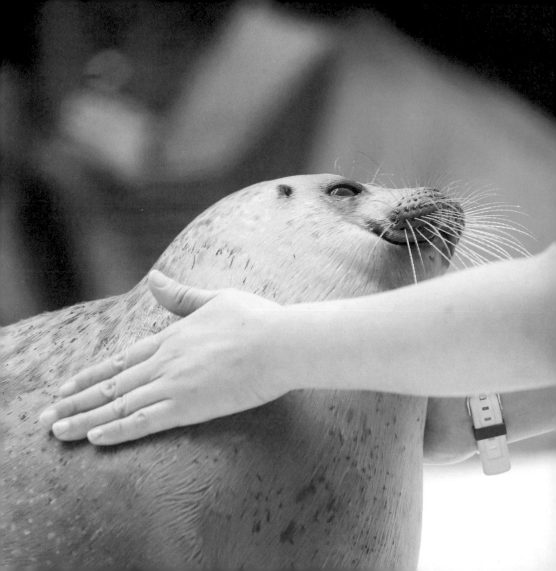

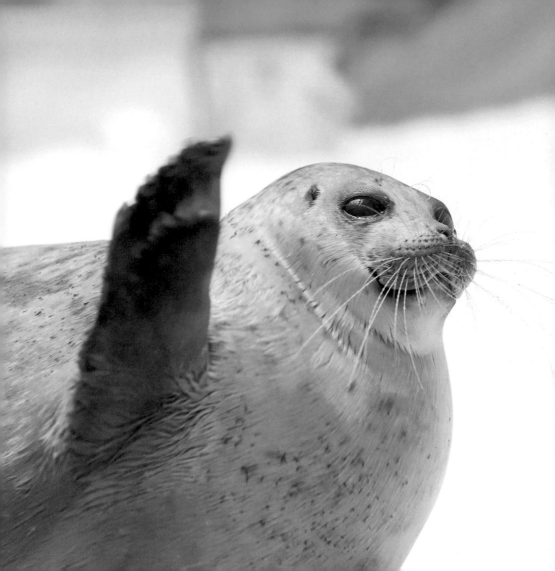

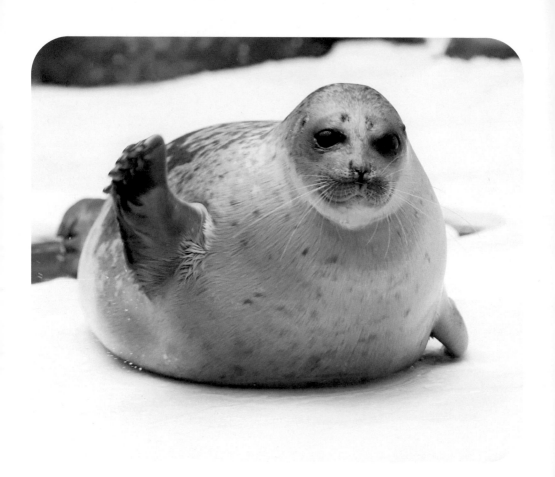

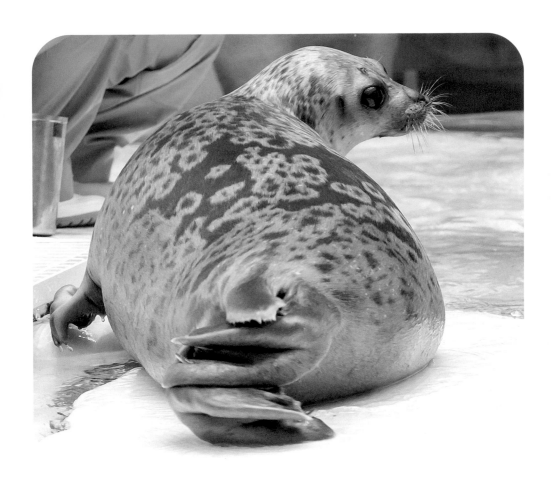

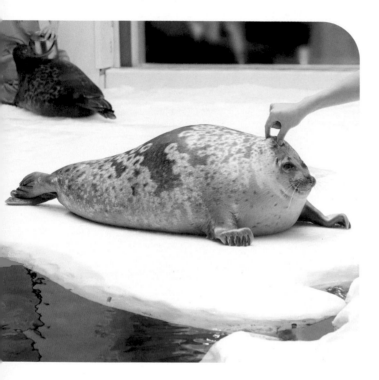

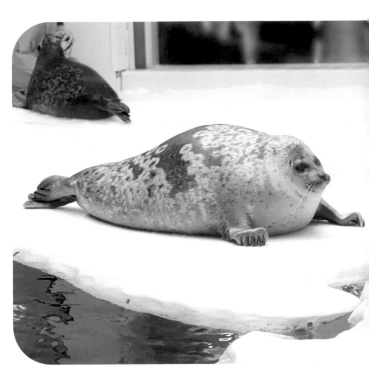

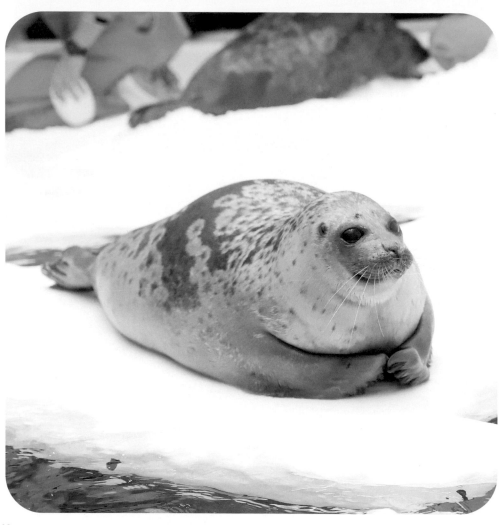

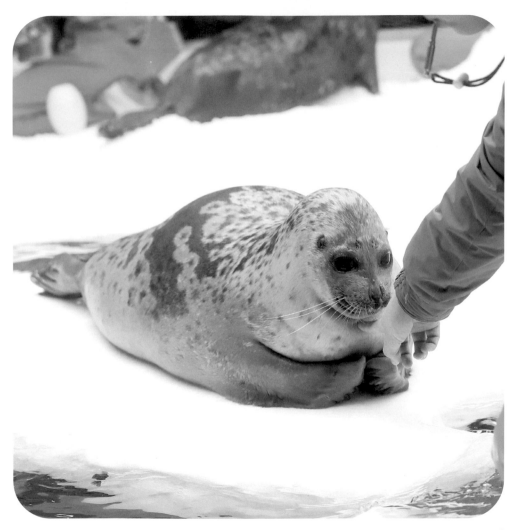

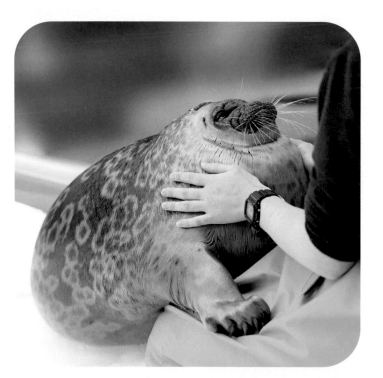

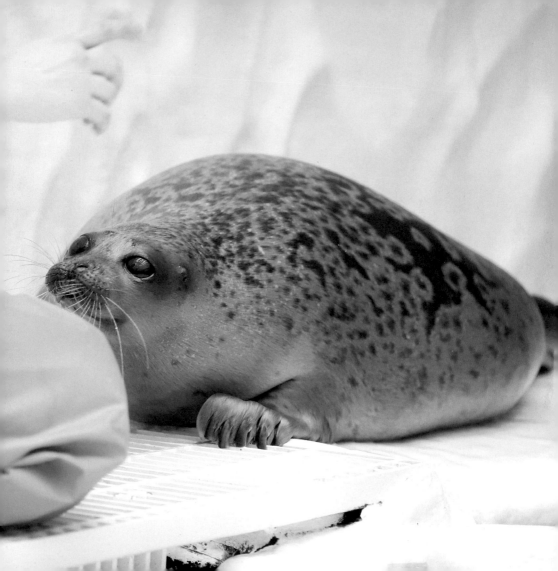

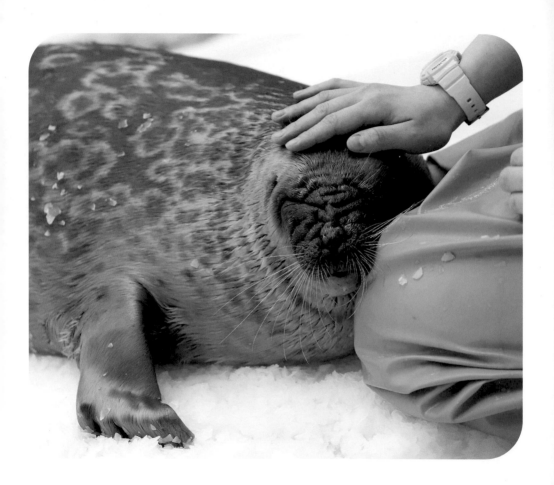

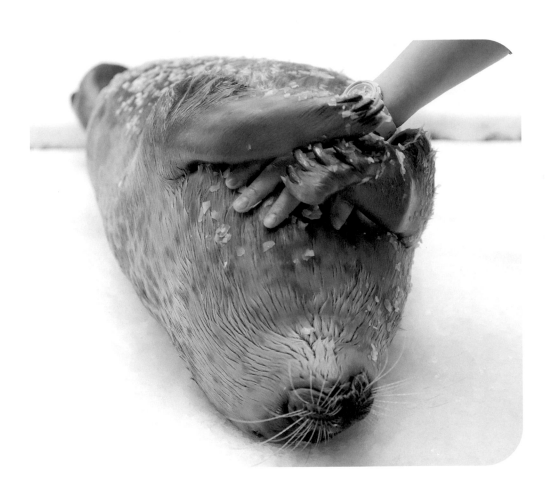

Meals are served to the animals twice a day at the Kaiyukan, at which time the staff also carries out husbandry training.

\ Handshake /

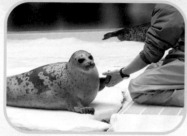

Staff check the animal's feet for any injuries, and also examine the animal's nails.

\ Body check /

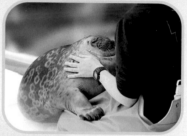

Staff check the animal's entire body for any injuries as well as for fur loss.

Checking neck \ range of motion /

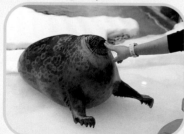

Staff examine the animal for any problems with the neck.

\ Eye medication /

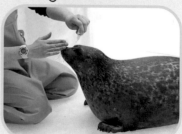

Any eye conditions are treated with medication.

Husbandry training in this case is all about teaching the animals to cooperate as the staff check on their physical condition.

\ Nose touch /

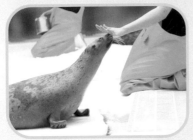

The animal is guided to focus on the training.

\ Open your mouth! /

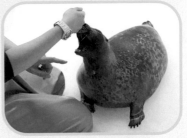

The animal's mouth is checked for any injury or for problems with their teeth.

Preparing to draw blood and \ take the animal's temperature /

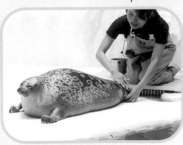

Thanks for cooperating with us. \ Now you get a treat! /

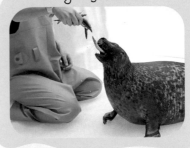

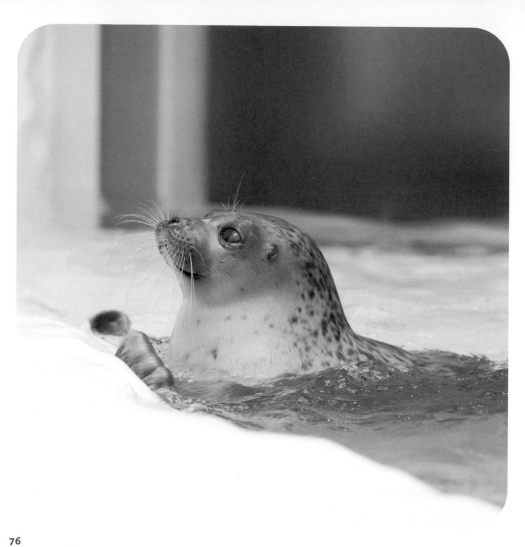

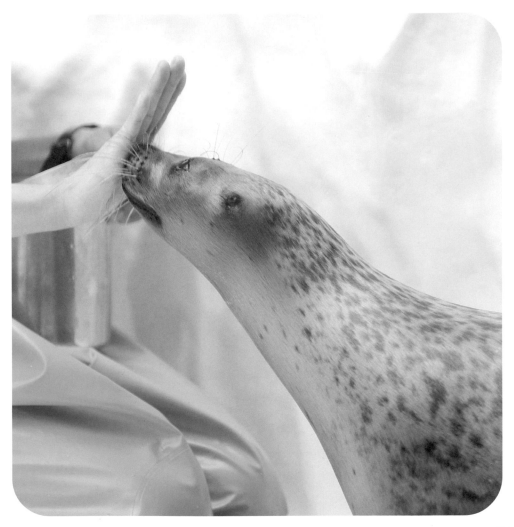

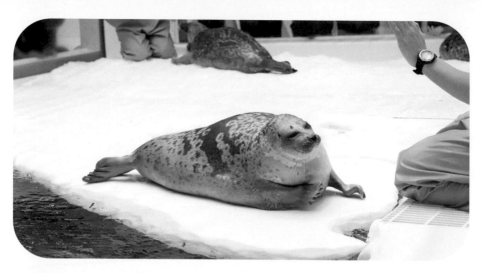

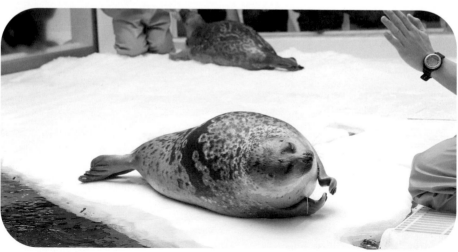

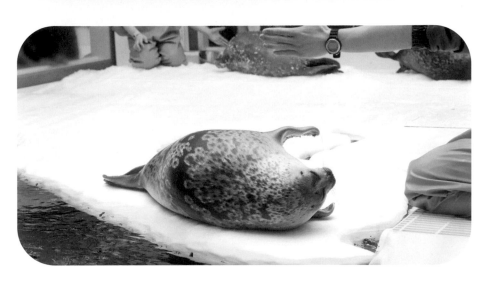

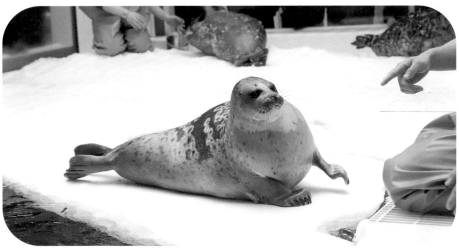

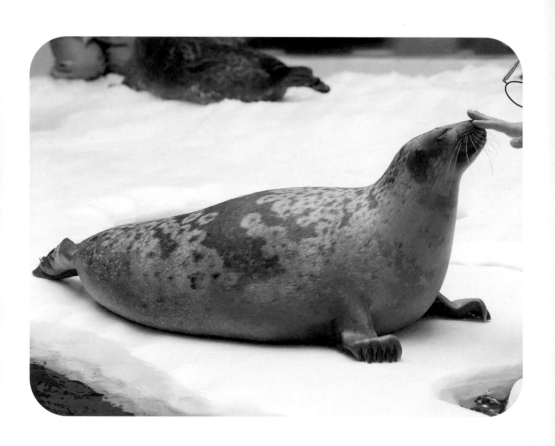

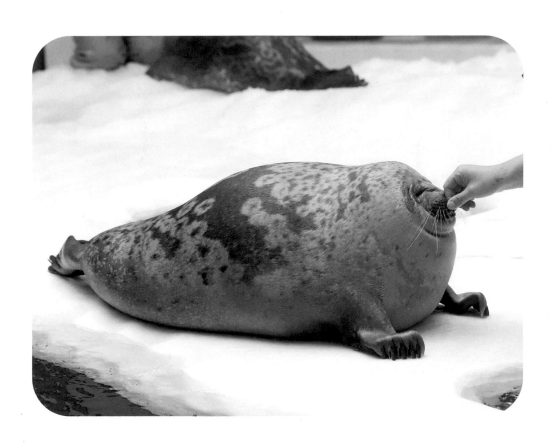

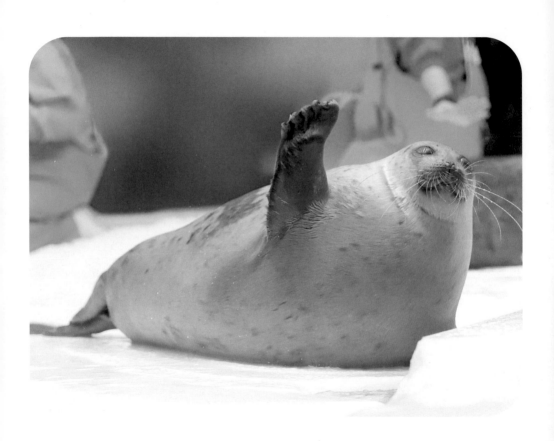

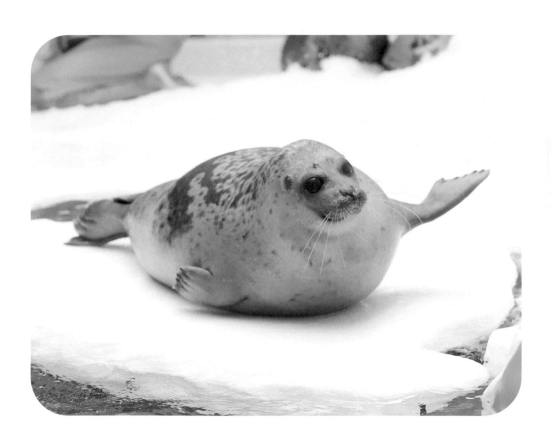

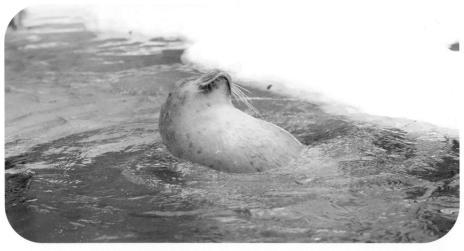

84

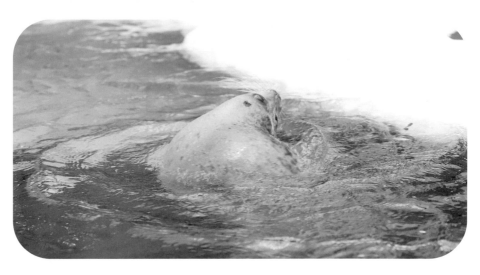

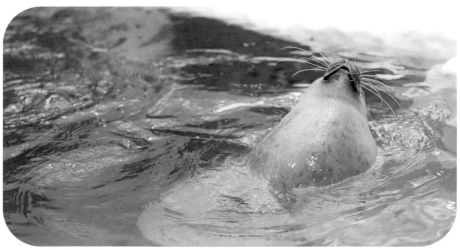

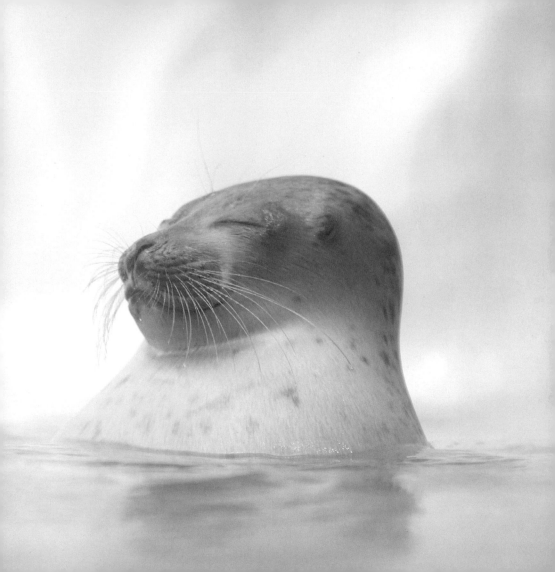

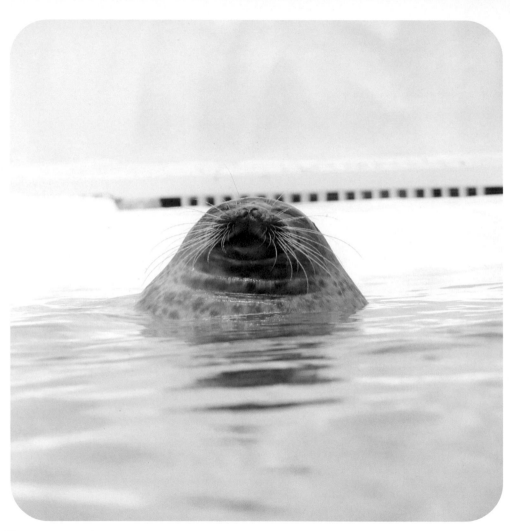

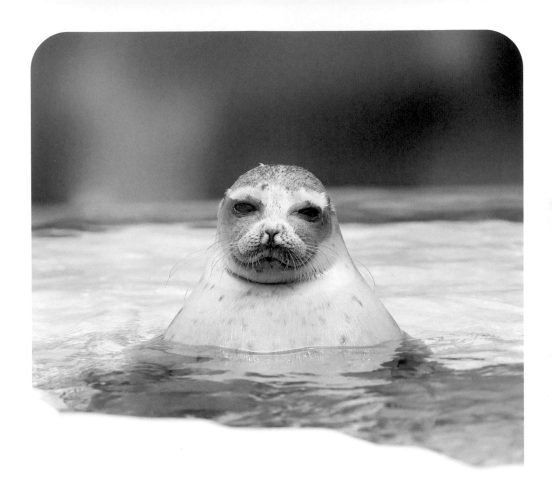

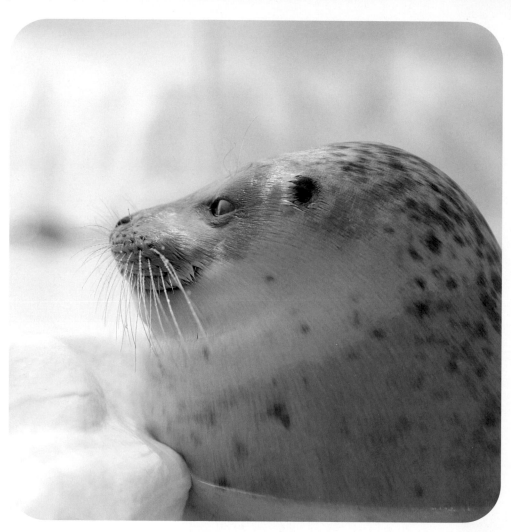

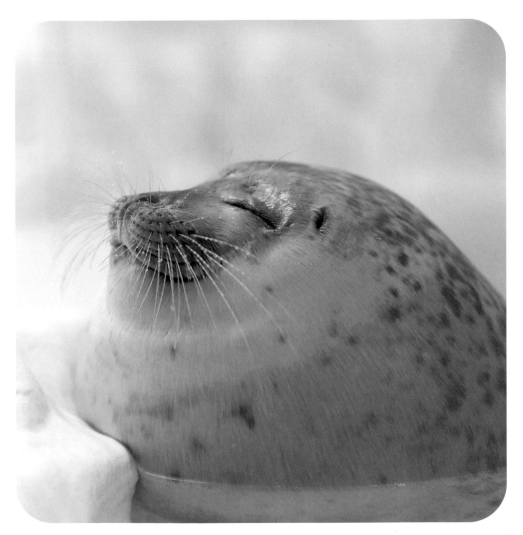

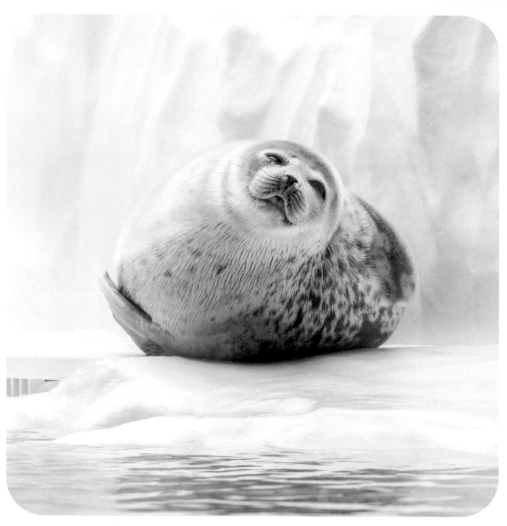

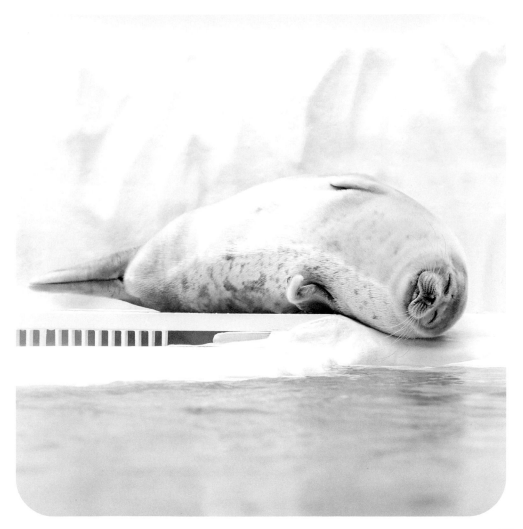

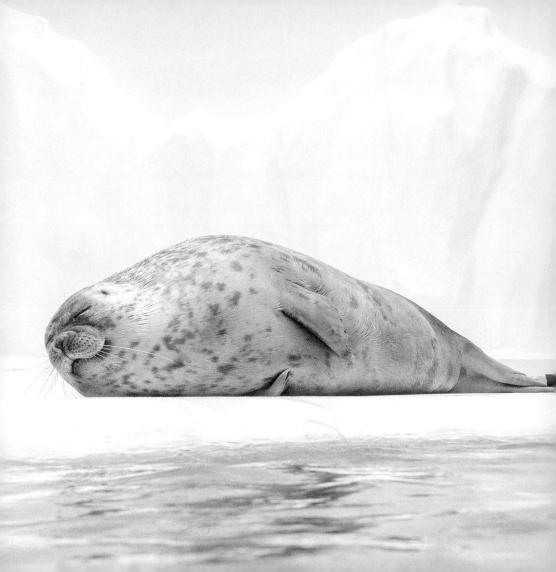

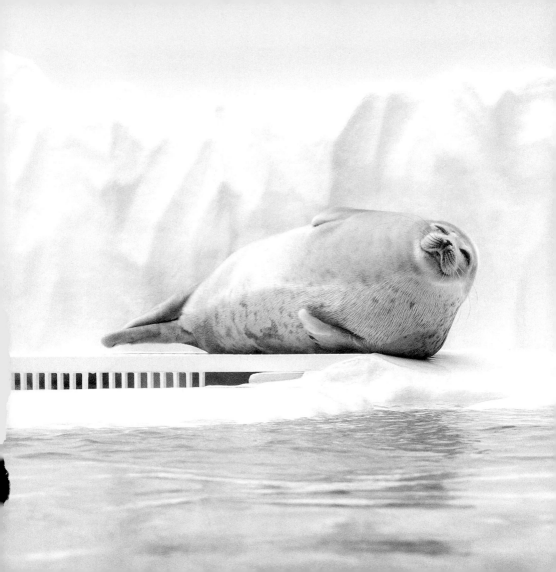

Come and meet Arare, Yuki, and Moya at one of the world's largest aquariums! Osaka Aquarium Kaiyukan

The Kaiyukan accurately recreates the natural environments of our planet, particularly the vast Pacific Ocean—the world's largest body of water—with a special emphasis on the Ring of Fire and the Ring of Life. The Arctic Circle exhibit features low, chest-height acrylic panels to help the visitor get a more realistic experience of the habitat of the ringed seal, including factors such as the actual temperature of the region as well as its sounds, such as crackling ice.

1-1-10 Kaigandori, Minato-ku, Osaka City, Osaka, Japan
Hours and days closed differ depending on the season. Check the Website for details:
https://www.kaiyukan.com

Author
Chiho Kuwada
Born in Hiroshima Prefecture, Chiho has been taking pictures of Arare, a ringed seal, since 2018.

Bibliography: *Kaitei Shinpan Sekaibunka Seibutsu Daizukan Dobutsu* [Sekaibunka Publishing's Encyclopedia of Organisms: Animal (Revised New Edition)]. Tokyo, Sekaibunka Publishing, 2004.

Roly-poly Round Seals!

First English edition published in August 2021
by PIE International Inc.,
2-32-4 Minami-Otsuka, Toshima-ku, Tokyo, Japan 170-0005
www.pie.co.jp/english
international@pie.co.jp

Author: Chiho Kuwada
Original Japanese edition design: Akiko Shiba (PIE Graphics)
Editor: Masumi Ikeda (PIE International)

English edition:
Cover Design: Akiko Shiba (PIE Graphics)
Translation: Leslie Higley (Designcraft)
Typesetting: Andrew Pothecary (itsumo music)
Production: Aki Ueda (Pont Cerise)

Original Japanese edition
© 2020 Chiho Kuwada / PIE International Inc.
The English edition
© 2021 Chiho Kuwada / PIE International Inc.

ISBN: 978-4-7562-5474-0

First Printing in June 2021

Printed and bound in China